301

THINGS
TO DRAW

301

THINGS
TO DRAW

chartwell
books

CALLING ALL ARTISTS!

Do you have trouble coming up with ideas, or struggle with issues like art block? Then these prompts are just what you need to pull you out of your slump!

These 301 drawing ideas are designed to get your creative juices flowing through sketching items from everyday life to more fantastical forms that will have your imagination running wild in no time. It's good to know how to draw the mundane and the whimsical as both can help you create your own original characters and environments.

Tapping into the deep recesses of your mind while looking at the prompts is important for your development as both an artist and critical thinker. Daydreaming and letting your mind wander are essential to harnessing your own personal techniques.

To help clear your art block, draw some of these 301 items in different and unique styles. Try drawing a prompt upside down or with your eyes closed, or even attempt to create a piece using just a single continuous line. Another idea is to try combining the prompts on the page together to create one large scene complete with a variety of characters.

Art is a spectrum and there is something for everyone. Breaks and blocks are okay, but if it is something you love, it will always be there when you need it.

Happy drawing!

1. Coral Reef

2. Swing

4. Crown

5. Wishing Well

6. OC (Original Character)

7. Umbrella

. .

8. Puddle Reflection

9. Wasp or Bee

. .

10. Honeycomb

11. Shipwreck

12. Zen Garden

13. Lighthouse

14. Camera

15. Something in Front of You

. .

16. Cat

17. Treefrog

18. Wolf

19. Bunny

20. Mermaid

21. Music Box

22. Windmill

23. Origami

24. Water Park

25. Flora & Fauna

26. Disco Ball

- -

27. Rollerblades

28. Lava Lamp

. .

29. Bubbles

30. Yin & Yang

31. Zentangle

32. Dreamcatcher

33. Rorschach Inkblot

35. Bonfire

. .

36. Campsite or Tent

37. UFO

. .

38. Cow

39. Moustache

40. Makeup

41. Haute Couture

42. Hoverboard

43. Fortune Teller

44. Moose

45. Figurines

47. Shattered Glass

- -

48. Spider Web

49. Scales

50. Lace

52. Maze

53. Horns or Antlers

. .

54. Salt & Pepper Shakers

55. Self Portrait

56. Bear Cub

57. Butter Dish

58. Fork

60. Balloon Animal

. .

61. Cherry Bomb

62. Clown

63. Fireworks

64. Basket of Berries

67. Koi Pond

. .

68. Jack 'o' Lantern

69. Movie Theatre

70. Pop Corn

71. Typewriter

. .

72. Film Reels

73. Skyscraper

. .

74. Sunflowers

75. Slippers

. .

76. Gown

77. Angel

78. Demon

79. Futuristic Travel

. .

80. Croissant

82. TV Remote

. .

83. TV

84. Sandwich

- -

85. Videogame Controller

86. Graffiti

87. Scissors

- -

88. Puzzle Pieces

89. Watermelon

90. Cupcake

91. Zeppelin

92. Vampire

94. Werewolf

. .

95. Sword

96. Thimble

97. Fairy

98. Mushrooms

. .
99. Button

100. Robot

101. Light Switch

102. Vending Machine

103. Roller Coaster

104. Skeleton

105. Blender

- -

106. Milkshake

107. Bar Stool

108. French Fries

109. Yeti

110. Planet

. .

111. Pizza

112. Festival

113. Ticket

115. Pretzel

116. Pencil

· ·

117. Paintbrush

118. Propeller Plane

· ·

119. Dancer

121. Unicorn

123. Alphabet Blocks

124. Porcelain Dolls

125. Teddy Bear

126. Crayons

128. Pyramids

129. Pebbles

130. Waterfall

. .

131. Waves

133. Potion

· ·

134. Cauldron

135. Candle

136. Skull

137. Sculpture or Statue

138. Rainbow

139. Castle

141. Mountain

. .

142. Succulent

143. Beach

. .

144. Surfboard

145. Manhole Cover

146. Newspaper Stand

147. Dragon

148. Glasses

149. Bridge

150. Cowboy Hat

152. Garden Gnome

153. Pool Float

154. Fence

155. Soda Can

158. Goddess

160. Scarf

161. Postcards

162. Polaroid Pictures

. .

163. Suitcase

164. Dollhouse

165. Boat

166. Goggles

167. Feather

· ·

168. Horse

169. Melting Ice Cream

170. Jellyfish

171. Fish

172. Clouds

. .

173. Telescope

174. Ghost

175. Watering Can

176. Praying Mantis

177. Throne

178. Meadow

. .

179. Narwhal

180. Toolbox

181. Drill

182. Workshop

183. Safe

184. Treehouse

185. Chessboard

186. Ray Gun

187. Gears

188. Vase

189. Milk Carton

190. Cookies

191. Holiday Decorations

192. Cuckoo Clock

193. Cityscape

194. Bike

195. Car

196. Walkie-Talkie

197. Bus

198. Pocket Watch

199. Crystal

200. Tooth

201. Herbs

202. Phone Booth

203. Fairy Lights

205. Alien

206. Photo Booth

. .

207. Smile + Toothbrush

208. Knit Sweater

209. Sewing Kit

210. Lamp

. .

211. Wine Glass

212. Loaf of Bread

213. Chair

214. Footprints

215. Forest

216. Lava

217. Bucket

218. Sandcastle

219. Seashell

. .

220. Picnic

221. Puppet

223. Eyes

224. Hands

225. Raven

226. Claws

227. Zombie

228. Graveyard

229. Shoes

230. Playing Cards

. .

231. Sloth

232. Teacup

233. Lantern

234. Coat Hanger

. .

235. Clothing Rack

236. Fan

. .

237. Laundry Hamper

238. Treasure Chest

239. Keys

241. Door

242. Tree Bark

243. Icicles

- -

244. Ice Skate

245. Snowman

246. Streetlight

247. Violin

249. Leaf

250. Tornado

251. Wig

. .

252. Facemask

253. Nail Polish

254. Bouquet of Flowers .

255. Bonsai Tree

256. Bat

257. Bird Nest

257. Garbage Can

259. Avocado

260. Backpack

- -

261. Water Bottle

263. Lock

264. Crevice

265. Computer

266. Button-Up Shirt

267. Fire Hydrant

268. Ladder

269. Pigeon

270. Scooter

271. Pan Flute

272. Moon & Stars

273. Rosebud

274. Snail

275. Orange Slices

276. Talisman

277. Bow & Quiver

278. Book

279. Wizard's Wand

280. Candy Wrappers

283. Locket

284. Record Player

285. Headphones

286. Guitar

. .

287. Flip Phone

288. Stethoscope

289. Chainsaw

290. Donut

291. Snowflake

292. Soap

. .

293. Bathtub

294. Lily Pads

. .

295. Windowsill

296. Butterflies

. .

297. Sunrise or Sunset

298. Staircase

299. Asymmetrical

. .

300. Bird Eye's View